SCHOOL IS HELL

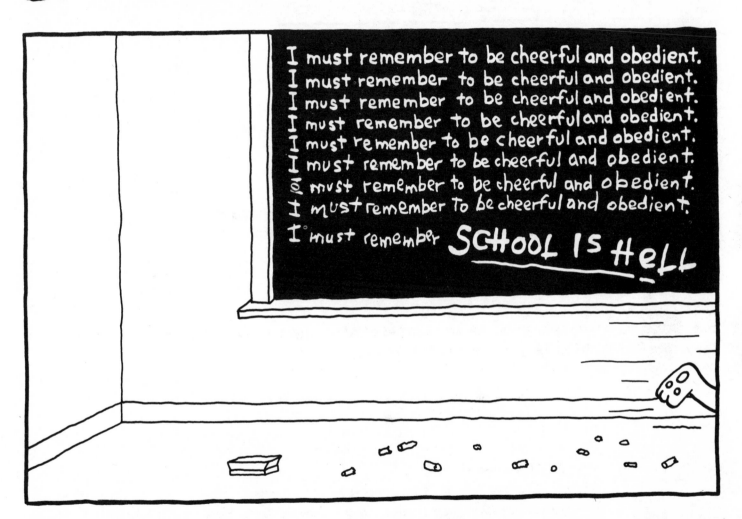

I must remember to be cheerful and obedient.
I must remember to be cheerful and obedient.
I must remember to be cheerful and obedient.
I must remember to be cheerful and obedient.
I must remember to be cheerful and obedient.
I must remember to be cheerful and obedient.
I must remember to be cheerful and obedient.
I must remember to be cheerful and obedient.
I must remember SCHOOL IS HELL

A CARTOON BOOK BY MATT GROENING

OTHER BOOKS BY MATT GROENING

LOVE IS HELL
WORK IS HELL

FORTHCOMING POSSIBLY

AKBAR & JEFF JOIN THE ARMY
AKBAR & JEFF GO AWOL
AKBAR & JEFF ON THE CHAIN GANG
AKBAR & JEFF ON THE RUN
AKBAR & JEFF FLOATIN' DOWNSTREAM
ROASTIN' MARSHMALLOWS WITH AKBAR & JEFF
A NEW FEZ FOR AKBAR
A NEW FEZ FOR JEFF
FEZZES FOR ALL!

DEDICATED TO MY PARENTS, HOMER AND MARGARET GROENING, DESPITE THE SCHOOLS I HAD TO GO TO

(First published in the USA by Pantheon Books, a division of Random House Inc)

A Virgin Book
Published in 1988
by the Paperback Division of
W. H. Allen & Co. Plc
44 Hill Street
London W1X 8LB

Printed and bound in Great Britain by Anchor Brendon Ltd, Tiptree, Essex.

ISBN 0 86369 281 8

BACK COVER DESIGN: MILI SMYTHE

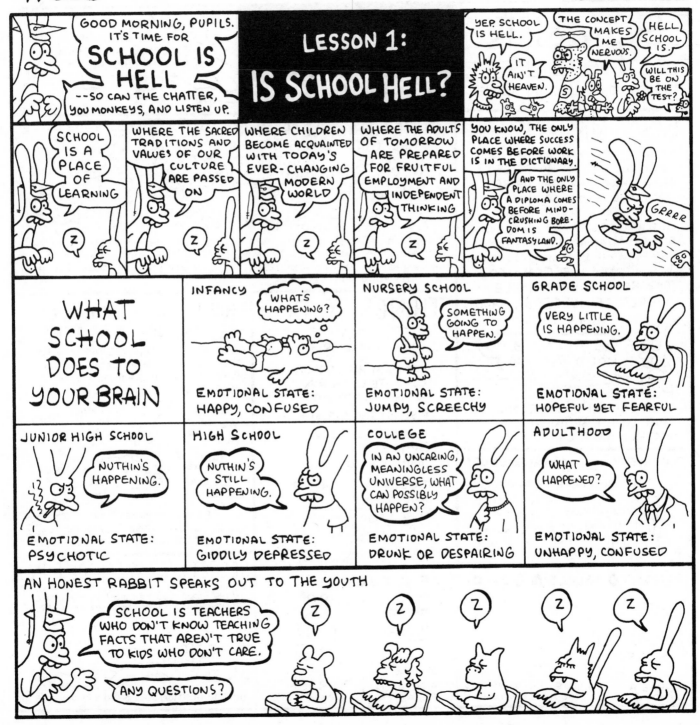

LIFE IN HELL

School Is Hell
AN EDUCATIONAL CARTOON MINISERIES

LESSON 2: NURSERY SCHOOL — THE HELLISHNESS BEGINS

CHEER UP, MY LITTLE ONE. YOU HAVE ONLY 14 TO 18 YEARS OF SCHOOL TO GO.

OH BOY! NURSERY SCHOOL!

AT LAST! AN ESCAPE FROM HOME, FROM THE ENDLESS HOURS OF TV GAME SHOWS AND SOAP OPERAS, FROM THE TEDIOUS CRAWLING OVER THE SAME BORING FLOORS, WATCHING THE SAME BORING DUST BALLS -- AN ESCAPE FROM ISOLATION AND FORCED NAPS AND HIDDEN COOKIES. WELCOME! WELCOME TO THE ROUGH-AND-TUMBLE WORLD OF NURSERY SCHOOL HIGH JINKS!

YOU MEAN TO SAY IT'S NOT A JAIL FOR CHILDREN?

FOR GOODNESS' SAKE, NO. THAT WON'T BEGIN FOR ANOTHER YEAR OR TWO.

FATIGUED? NERVOUS? FREAKED OUT?

TRY ROCKING BACK AND FORTH, ROLLING YOUR HEAD AROUND, SUCKING YOUR THUMB, OR CLUTCHING AT YOUR GENITALS. DRIVES ADULTS CRAZY.

THOSE OTHER LITTLE CREATURES -- ARE THEY DEMONS, OR WHAT?

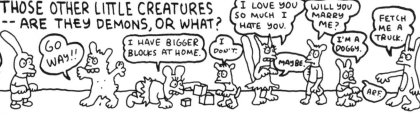

HI.

GO WAY!!

I HAVE BIGGER BLOCKS AT HOME.

I LOVE YOU SO MUCH I HATE YOU.

I DON'T.

MAYBE

WILL YOU MARRY ME?

I'M A DOGGY.

FETCH ME A TRUCK.

ARF

THOSE LITTLE CREATURES WHO ARE POKING, PINCHING, AND HITTING YOU ARE NOT MONSTERS, ANIMALS, OR TV IMAGES -- THEY ARE SMALL, POWERLESS HUMAN BEINGS JUST LIKE YOURSELF. YOU MIGHT WISH TO POKE, PINCH, AND HIT THEM TO MAKE SURE.

THINGS TO DO

1. FORM SMALL TRIBES.
2. SET UP A HIERARCHY, COMPLETE WITH RULES, BOSSES, AND TABOOS.
3. DISDAIN THE OPPOSITE SEX.
4. FORAGE AND HOARD (BLOCKS, DOLLS, ETC.)
5. BRUTALIZE OUTSIDERS.
6. TAKE BREAKS FOR JUICE AND COOKIES.

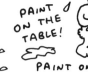

YOU'RE A DOODY DUM-DUM DING-DONG!!

TRUE-- BUT CAN I JOIN ANYWAY?

THIS IS PROBABLY YOUR LAST CHANCE TO BE ARTISTIC

THAT'S RIGHT!! SEIZE THE OPPORTUNITY TO EXPERIMENT WITH GLEEFUL ABANDON, BEFORE THEY SHOW YOU HOW TO DO IT RIGHT, AND RUIN EVERYTHING.

HOLD A BRUSH IN EACH HAND!

SEE WHAT PAINT TASTES LIKE!

PAINT ON THE TABLE!

PAINT ON THE FLOOR!

PAINT ON OTHER KIDS!

PAINT ON YOURSELF!

SPEND THE REST OF YOUR LIFE FUTILELY TRYING TO RECAPTURE THIS SPONTANEITY!

HOW TO MAKE A GUN OUT OF A COOKIE

1. GRAB A COOKIE.

2. BITE THE COOKIE INTO THE SHAPE OF A GUN.

BANG BANG!!

3. FIRE WHEN READY.

HERO OF THE NURSERY SCHOOL!

SECRET NURSERY SCHOOL FUN

DURING NAPTIME, LIE ON YOUR LITTLE BLANKET ON THE FLOOR AND FEIGN SLEEP. WHEN THE TEACHER WALKS BY, YOU CAN LOOK UP HER DRESS.

YOUR EDUCATION HAS NOW BEGUN.

LIFE IN HELL

School Iz Hell*

*NOTE GENERIC BACKWARDS "S" DYSLEXIC HUMOR, A COMMON SOURCE OF FRIVOLITY

LESSON 3:
THE WILD, WILD WORLD OF KINDERGARTEN

REMEMBER: WHAT'S LEARNT IN THE CRADLE LASTS TILL THE TOMB.

TOMB? TOMB? WHAT'S THIS ABOUT A TOMB?

WELCOME! WELCOME TO KINDYGARDEN, OR, AS SOME OF THE LESS MATURE AMONG YOU CALL IT, KINDY GARDY. THAT'S RIGHT! NO MORE WIMPY LITTLE BABY SCHOOL FOR LITTLE BABIES-- THIS IS THE BIG TIME.

(t-shirt: HERE COMES TROUBLE)

WHAT THEY DO TO YOU IN KINDYGARDER

FIRST, THEY MAKE YOU LEAVE ALL YOUR COOL SHINY WAR TOYS AND SEXY PLASTIC DOLLS AT HOME. INSTEAD, THEY GIVE YOU A BUNCH OF CLUNKY, DIRTY, WORN, BORING TOYS MADE OUT OF DUMB WOOD OR SOMETHING. TRUE, THESE TOYS HAVE FASCINATING CHEW MARKS ON THEM, BUT THEY ARE REALLY REALLY REALLY REALLY REALLY HARD TO BREAK. OKAY, THEN THE LADY MAKES YOU DO STUFF, LIKE MARCH AROUND AND SIT STILL AND SING SONGS AND LISTEN TO STORIES ABOUT BUNNIES. THE BUNNY STORIES CAN BE QUITE AMUSING, ACTUALLY. THEN YOU GO OUTSIDE TO PLAY. GO FOR THE SWINGS--THEY'RE THE FUNNEST. THEN IT'S BACK INSIDE FOR CRACKERS AND WARM JUICE. YOU CAN CAUSE A RUCKUS BY CALLING IT "WORM JUICE."

KINNERGARDEN IS THE LAST PLACE YOU'LL BE ABLE TO ASK ANY QUESTION THAT COMES TO MIND WITHOUT FEAR OF GETTING SMACKED IN REPLY.

CAN DOGS MEOW?

IS UP DOWN?

IS TOMORROW TODAY?

WHY IS YOUR NOSE SO BIG?

WILL YOU BE DEAD WHEN I GROW UP?

IF GOD IS EVERYWHERE, IS HE IN THE TOILET?

CAN CATS OINK?

WARNING
YOU MAY BE SMACKED ANYWAY.

BIG MEAN GROWN-UPS AND THEIR SNEAKY TRICKS

THEY WILL TRY TO GET YOU TO INCRIMINATE YOURSELF.

DID YOU BREAK THOSE BOTTLES?

NO!!!!

IT IS EASY TO SEE THROUGH THIS TACTIC.

BEWARE OF THEIR CRAFTY MANEUVERS. DON'T LET THEM CATCH YOU OFF-GUARD.

HOW DID YOU BREAK THOSE BOTTLES?

I PUSHED THEM OFF THE TABLE.

A COMMON BLUNDER.

HERE'S THE TRIED-AND-TRUE RESPONSE TO ALL BLAME-SEEKING QUERIES.

WHO BROKE THOSE BOTTLES?

HE DID!!!

SO KINDYGARTER IS FUN, EVEN THOUGH THEY DON'T HAVE ANY TV THERE AND THE BIG LADY TALKS TOO MUCH AND SHE PINS NOTES TO YOUR CLOTHES BECAUSE SHE THINKS YOU'RE SO STUPID YOU'LL LOSE 'EM ON THE WAY HOME. THE GOOD PART IS KINNERGARTEN LASTS FOREVER BUT THE BAD PART IS IT REALLY DOESN'T.

(L'IL STINKER)

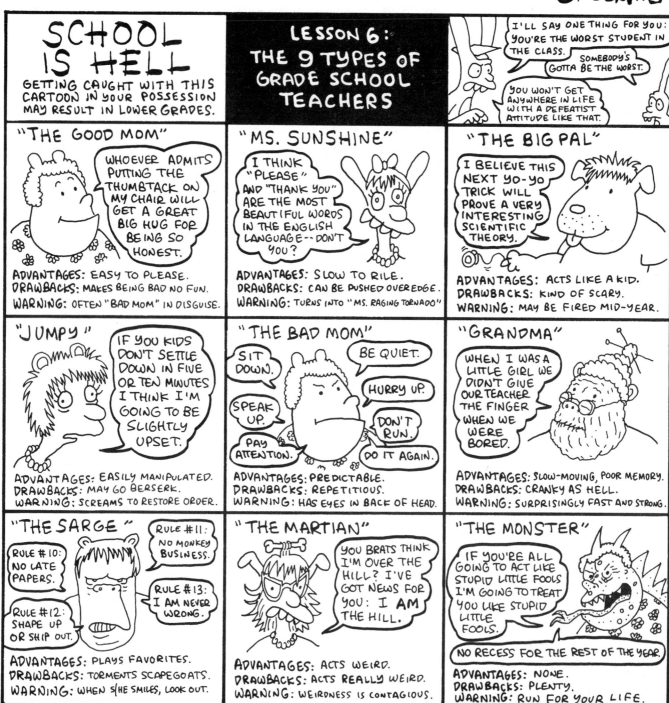

LIFE IN HELL

SCHOOL IS HELL
(SCHOOL IS HELL)

LESSON 8: TROUBLE: GETTING IN AND WEASELING YOUR WAY OUT OF.

WHEN IN DOUBT, HOWL YOUR INNOCENCE.

- NO WAY
- I DIDN'T DO NUTHIN
- I BEEN FRAMED
- LEMME SEE MY LAWYER

WHAT IS TROUBLE?

THE EXPERTS EXPLAIN.

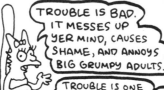

TROUBLE IS BAD. IT MESSES UP YER MIND, CAUSES SHAME, AND ANNOYS BIG GRUMPY ADULTS.

TROUBLE IS ONE OF THE LEADING CAUSES OF SPANKINGS IN THE WORLD TODAY.

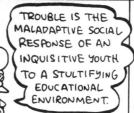

TROUBLE IS THE MALADAPTIVE SOCIAL RESPONSE OF AN INQUISITIVE YOUTH TO A STULTIFYING EDUCATIONAL ENVIRONMENT.

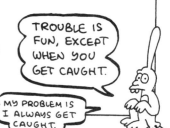

TROUBLE IS FUN, EXCEPT WHEN YOU GET CAUGHT.

MY PROBLEM IS I ALWAYS GET CAUGHT.

BASIC TROUBLE

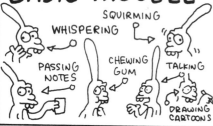

- SQUIRMING
- WHISPERING
- PASSING NOTES
- CHEWING GUM
- TALKING
- DRAWING CARTOONS

ADVANCED TROUBLE

HIDING ALL THE BLACKBOARD ERASERS

STEALING BACK YOUR CONFISCATED YO-YO FROM THE TEACHER'S DESK

SQUIRTING WATER ON THE TEACHER'S CHAIR

THROWING WATER BALLOONS

VERY ADVANCED TROUBLE

DROPPING A BAG OF BALL BEARINGS ON THE FLOOR

PUTTING SNAILS IN THE TEACHER'S BRIEFCASE

LAUGHING AT EVERYTHING THE TEACHER SAYS

THROWING MAPLE-SYRUP BALLOONS

CAN TROUBLE BE AVOIDED?

MANY YOUNGSTERS ATTEMPT TO AVOID TROUBLE BY SEEKING REFUGE IN A SEAT IN THE REAR CORNER OF THE CLASSROOM.

UNFORTUNATELY, IN RECENT CENTURIES MANY AUTHORITIES HAVE BECOME AWARE OF THIS HIDE-OUT.

TRY NOT TO LOOK GUILTY

HALF-ASLEEP = INNOCENT

ANGELIC = GUILTY AS HELL

IF YOU ARE CAUGHT

TRY ONE OR MORE OF THE FOLLOWING.

ACT SO SHOCKED THAT YOU ARE RENDERED TEMPORARILY SPEECHLESS.

THIS WILL BUY YOU TIME WHILE YOU THINK OF A WAY OUT.

DENY EVERYTHING. BLAME SOMEONE ELSE. LOOK SINCERE. STICK TO YOUR STORY. DON'T FALTER. LIE LIKE CRAZY.

CONFESS -- WITH AS FEW DETAILS AS POSSIBLE. LOOK PATHETIC. WHIMPER. BEG FOR MERCY. SWEAR YOU'LL NEVER DO IT AGAIN.

IMPORTANT: DON'T FORGET TO KEEP YOUR FINGERS CROSSED.

LIFE IN HELL

SCHOOL IS HELL

THE LINGERING EFFECTS OF HAVING ONE'S CARTOONS CONFISCATED IN THE 6th GRADE

LESSON 9: HOW TO DRIVE A DESERVING TEACHER CRAZY

3 ANNOYING WAYS TO ASK TO GO TO THE LAVATORY

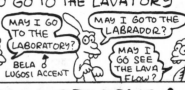

MAY I GO TO THE LABORATORY? — BELA LUGOSI ACCENT

MAY I GO TO THE LABRADOR?

MAY I GO SEE THE LAVA FLOW?

DON'T ALL TEACHERS DESERVE TO BE DRIVEN CRAZY?

STRANGELY, THE ANSWER IS NO. WE MUST REMEMBER THAT TEACHERS USED TO BE SMALL AND SPEEDY, JUST LIKE US. BUT THEN THEY GREW UP, GOT SOPHISTICATED, AND WENT SENILE.

IF THEY ARE NICE AND FUNNY AND TEACH US A THING OR TWO, THEN WE SHOULD TAKE PITY ON THE POOR UNDERPAID DRUDGES AND GIVE 'EM A BREAK. UNLESS WE'RE IN A RAMBUNCTIOUS MOOD.

HOW TO TELL IF A TEACHER DESERVES TO BE DRIVEN CRAZY
A CHECKLIST

☐ CALLS ON YOU WHEN YOU ARE SCRUNCHED DOWN IN YOUR SEAT TRYING TO LOOK AS INCONSPICUOUS AS POSSIBLE.

☐ LOCKS THE CLASSROOM DOOR WHEN THE BELL RINGS AND WON'T OPEN UP NO MATTER HOW HARD YOU KICK

☐ NEVER SMILES

☐ SMILES TOO MUCH

☐ PUNISHES YOU UNFAIRLY

☐ PUNISHES YOU FAIRLY

MAKING A CRAZY TEACHER CRAZIER -- THE CYCLE

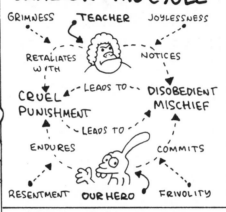

GRIMNESS → TEACHER → JOYLESSNESS

RETALIATES WITH — NOTICES

CRUEL PUNISHMENT — LEADS TO — DISOBEDIENT MISCHIEF

ENDURES — LEADS TO — COMMITS

RESENTMENT — OUR HERO — FRIVOLITY

SMALL WAYS TO DRIVE A DESERVING TEACHER CRAZY

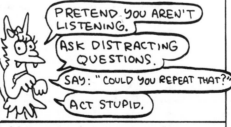

PRETEND YOU AREN'T LISTENING.

ASK DISTRACTING QUESTIONS.

SAY: "COULD YOU REPEAT THAT?"

ACT STUPID.

MEDIUM-SIZED WAYS TO DRIVE A DESERVING TEACHER CRAZY

HIDE ALL THE BLACKBOARD ERASERS.

MAKE LITTLE MEOWING NOISES WITHOUT MOVING YOUR LIPS.

ACT SMART.

BIG WAYS TO DRIVE A DESERVING TEACHER CRAZY

SQUIRT WATER ON THE TEACHER'S CHAIR WHEN SHE ISN'T LOOKING.

SMUGGLE AS MANY DOGS AS YOU CAN INTO THE CLASSROOM.

SAY THINGS THAT MAKE THE CLASS LAUGH BUT WHICH THE TEACHER DOESN'T GET.

IF YOU GET KICKED OUT OF CLASS, YOU CAN STILL DRIVE A DESERVING TEACHER CRAZY

① GATHER YOUR STUFF AS SLOWLY AS POSSIBLE.

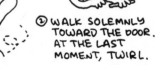

② WALK SOLEMNLY TOWARD THE DOOR. AT THE LAST MOMENT, TWIRL.

③ SLAM THE DOOR AND MAKE GOOFY FACES IN THE LITTLE WINDOW. THEN RUN.

④ WAIT 20 YEARS, THEN DRAW A BOOK OF SNOTTY CARTOONS ABOUT SCHOOL.

DOOP DE DOO ♪

SCHOOL IS HE

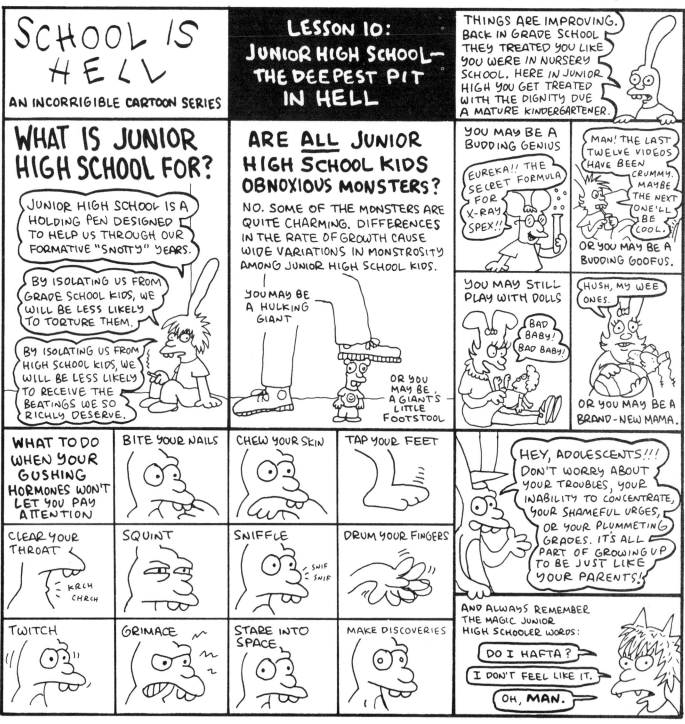

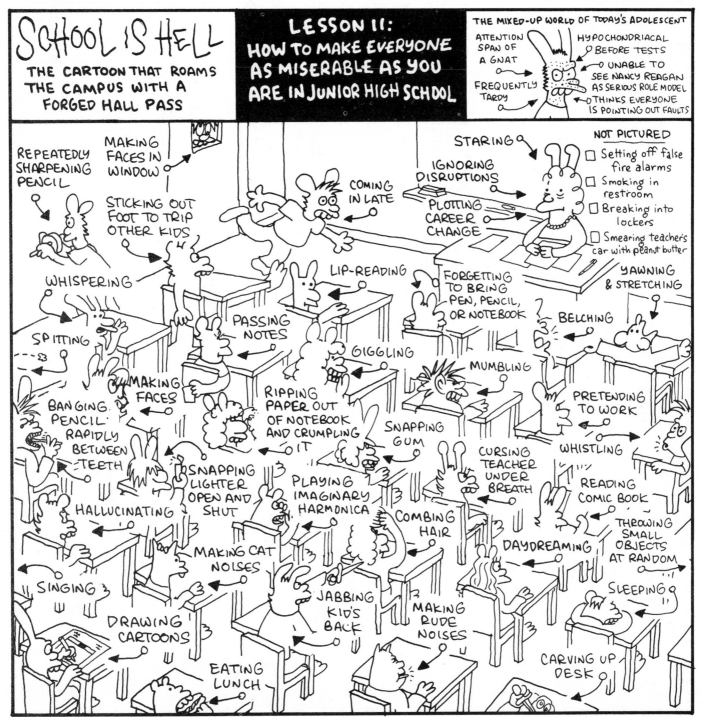

LIFE IN HELL

SCHOOL IS HELL
THE CARTOON WITH IDENTIFIABLE PERCEPTUAL COMMUNICATIVE DISORDERS

LESSON 12: HIGH SCHOOL— THE 2ND DEEPEST PIT IN HELL

3 USELESS THINGS

 STUDY HALL

 HISTORY FOR 16-YEAR-OLDS — TEXTBOOKS

 GUIDANCE COUNSELORS

WELCOME TO HIGH SCHOOL

Panel 1: FOR YEARS WE'VE BEEN WATCHING YOU, GRADING YOU, TESTING YOU, KEEPING SECRET FILES ON YOU-- AND YOU'LL BE GLAD TO KNOW YOU'RE NORMAL! THERE'S NOTHING TO WORRY ABOUT.

Panel 2: YOU'RE UNSPECIAL, UNREMARKABLE, AND THOROUGHLY AVERAGE. YOU PROBABLY DON'T EVEN REALIZE IT, BUT WE'VE DEVELOPED A SERIES OF UNDEMANDING CLASSES TAUGHT BY TEACHERS WHO WERE ONCE JUST LIKE YOU.

Panel 3: YOUR JOB IS TO SHOW UP, NOT WRECK ANYTHING, AND STAY JUST THE WAY YOU ARE. AS A REWARD, WE'LL GIVE YOU A DIPLOMA. WE KNOW YOU CAN DO IT.

TIPS FOR TEENS

WHY NOT GET A JOB AT NIGHT AND LEARN THE WONDERS OF DEEP FRYING, SECRET SAUCE, MINIMUM WAGE, AND SLEEPING IN SCHOOL?

CONTEMPORARY EXCUSES FOR NOT HAVING DONE YOUR HOMEWORK

- THE PRINTER BROKE!
- THE FLOPPY DISK WAS DEFECTIVE!
- I PUSHED THE WRONG BUTTON AND DELETED EVERYTHING!

HOW HARD DO YOU WANT TO STUDY?

TYPE OF COURSE	DEGREE OF HAPPINESS	DEGREE OF DIFFICULTY	BEST SUITED FOR KIDS WHO ARE:
HONORS	🙂	KINDA EASY	WHIZZY, CRAZY
COLLEGE PREP	😐	FAIRLY EASY	DIZZY, BUSY
GENERAL	🙁	REAL EASY	BREEZY, LAZY
BASIC	😠	BEYOND EASY	CHEESY, SLEAZY

DID YOU KNOW?
SHOPPING MALLS ARE ACTUALLY KIND OF BORING AFTER AWHILE.

WARNING!
DO **NOT** TALK TO TEACHERS IN THE SAME TONE OF VOICE THEY USE TALKING TO YOU. YOU WILL BE SUSPENDED FOR INSOLENCE.

TIPS FOR TEENS
IF SOMEONE DROPS HIS OR HER STUFF IN THE RUSH BETWEEN CLASSES, BE SURE TO STOMP ON IT. AN ENTIRE YEAR'S WORK CAN BE TRAMPLED, RIPPED, AND DESTROYED IN A MATTER OF SECONDS IF EVERYONE COOPERATES.

DID YOU KNOW?
The best work is that which is done at the last minute.

TIPS FOR TEENS
REMEMBER! MOST TEACHERS ARE EAGER TO PLAY THE GAME "I WON'T MESS WITH YOU IF YOU DON'T BUG ME."

THINGS TO WORRY ABOUT IN HIGH SCHOOL	THINGS NOT TO WORRY ABOUT IN HIGH SCHOOL
STATUS	
SEX	
CLOTHES	
GRADES	
DRINKING CAPACITY	SCHOOL SPIRIT
KILLING YOURSELF	
GRADUATION	
YOUR FACE	

LIFE IN HELL

SCHOOL IS HELL

AND DON'T YOU FORGET IT

LESSON 13: THE 9 TYPES OF HIGH SCHOOL TEACHERS

WHO, ME?

THE KID

GOSH, KIDS!!

ALSO KNOWN AS: DUDE, SQUIRT, JUNIOR.
BASIC MOODS: FRISKY, ENTHUSIASTIC.
WARNING: CAN BE AS CRUEL AS A TEEN-AGER.

THE PRIG

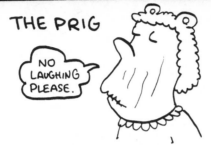

NO LAUGHING PLEASE.

ALSO KNOWN AS: OLD IRONSIDES, PRUNEFACE.
BASIC MOODS: HUMORLESS, IRRITATED.
WARNING: WILL PENALIZE YOU FOR BLINKING.

THE HIPSTER

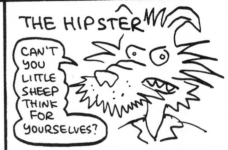

CAN'T YOU LITTLE SHEEP THINK FOR YOURSELVES?

ALSO KNOWN AS: THE WEIRDO, THE POET.
BASIC MOODS: AGITATED, NOSTALGIC.
WARNING: WILL MAKE YOU FEEL BAD ABOUT THE PROM.

THE FOSSIL

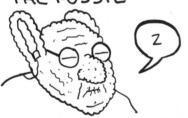

Z

ALSO KNOWN AS: THE CORPSE.
BASIC MOODS: ORNERY, ASLEEP.
WARNING: IT LIVES.

THE DIP

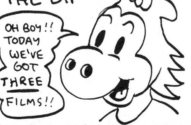

OH BOY!! TODAY WE'VE GOT THREE FILMS!!

ALSO KNOWN AS: EASY, THE BABYSITTER.
BASIC MOODS: DIZZY, OPTIMISTIC.
WARNING: MAKES YOUR BRAIN SLUGGISH.

THE JOCK

THAT REMINDS ME OF LAST NIGHT'S GAME.

ALSO KNOWN AS: BIG GUY, COACH, GRUNTY.
BASIC MOODS: MANLY, LOUD, CORNY.
WARNING: MAY DEMAND PUSH-UPS ON THE SPOT.

THE WONDER

NOW YOU GET IT!! YOU GUYS ARE SMART!! "A"s FOR EVERYONE!!!

ALSO KNOWN AS: THE MIRACLE.
BASIC MOODS: INSPIRED, GABBY.
WARNING: EXTREMELY RARE.

THE FANATIC

NO EXCUSES. I DON'T CARE IF YOUR GRANDMA DIED.

ALSO KNOWN AS: SCREAMY, SCREECHY.
BASIC MOODS: BAD, WORSE.
WARNING: NO WIN.

DER FUEHRER

GOOD MORNING, MY TROUBLED LITTLE LOSERS. YOU ALL FAILED YESTERDAY'S TEST.

ALSO KNOWN AS: PIG, CREEP, SCUM.
BASIC MOODS: SARCASTIC, GLEEFUL.
WARNING: THIS IS NOT A DREAM.

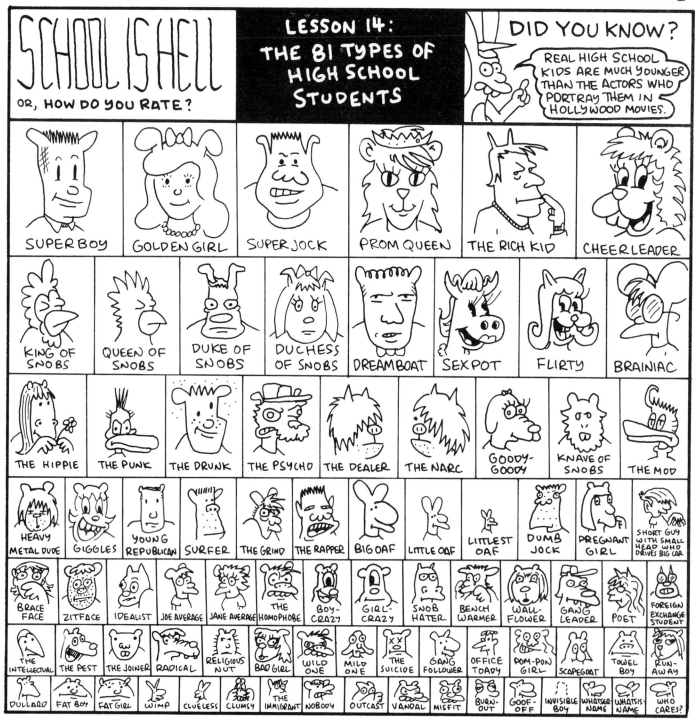

LIFE IN HELL

SCHOOL IS HELL
OR
I WAS A TEENAGED MALCONTENT

LESSON 15: HOW TO GET BY WHEN YER SMARTER THAN YER TEACHERS

WHAT NOT TO SAY TO YOUR GUIDANCE COUNSELOR

> IF YOU KNOW SO MUCH ABOUT MAKING INTELLIGENT CAREER DECISIONS, HOW COME YOU'RE A GUIDANCE COUNSELOR?

BE CAREFUL!!

IN AN AVERAGE 30-KID CLASS:

- → 15 KIDS ARE HALF-ASLEEP
- → 10 KIDS ARE TOTALLY ASLEEP
- → 5 KIDS ARE AWAKE

GUESS WHICH 5 KIDS THE TEACHER IS MOST SUSPICIOUS OF?

REMEMBER: TO THE SLOW, DIMWITTED BEAST KNOWN AS THE ASSISTANT PRINCIPAL,

SMART = UPPITY.

SO, WHEN YOU ARE SENT TO THE OFFICE FOR INSUBORDINATION, ACT ABASHED.

WRONG	RIGHT
THE CRIME IS NOT THAT I REBELLED, THE CRIME IS THAT THE OTHER KIDS DO NOT-- THAT THEY ARE TOO BORED AND DEFEATED TO CHALLENGE THE STULTIFYING RULES, THE ABUSE OF POWER, AND THE SHEER JOYLESSNESS OF EVERYDAY SCHOOL LIFE.	I'LL BE GOOD FROM NOW ON, SIR.

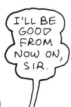

⇨ WISE UP ⇦

1. LOOK AROUND YOU. THE OTHER KIDS DON'T HAVE A CLUE.
2. SAME WITH TEACHERS.
3. SAME WITH PARENTS.
4. FIGURE IT OUT FOR YOURSELF.

HOW TO GET BY WHEN YER AS STUPID AS A ROCK MUSICIAN

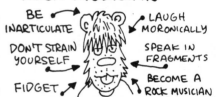

- BE INARTICULATE
- DON'T STRAIN YOURSELF
- FIDGET
- LAUGH MORONICALLY
- SPEAK IN FRAGMENTS
- BECOME A ROCK MUSICIAN

WORTHLESS THINGS IN HIGH SCHOOL

 ANY WORDS OF WISDOM BY THE PRINCIPAL

 ANYTHING MIMEOGRAPHED

 ANY ADVICE FROM A GUIDANCE COUNSELOR

 ANYTHING ANNOUNCED OVER THE P.A. SYSTEM

NEVER CORNER A TEACHER

ALTHOUGH GENERALLY DOCILE, TEACHERS HAVE BEEN KNOWN TO ATTACK SAVAGELY WHEN BACKED UP AGAINST A WALL.

REMEMBER, TEACHERS HATE SAYING:

> I DON'T KNOW.

AND THEY CANNOT EVER, EVER SAY:

> I'M SORRY.

HATE SCHOOL???

CONSOLE YOURSELF WITH THIS THOUGHT:

- AT LEAST YOU GET TO GRADUATE AND SCRAM.
- YOUR TEACHERS NEVER GRADUATE.
- THEY'RE STUCK HERE.

HOW TO GET BY WHEN YER NO SMARTER THAN YER TEACHERS

1. SIT TOWARDS THE BACK OF THE CLASS.
2. DON'T MOVE MUCH.
3. DON'T TALK MUCH.
4. NOD A LOT.
5. SMILE VACANTLY.

(YOU MAY WISH TO PURSUE A CAREER IN EDUCATION.)

NO MATTER HOW BAD IT GETS, DON'T KILL YOURSELF!!!!

 THEY WILL MAKE JOKES ABOUT YOU.

 DEATH LASTS EVEN LONGER THAN GRADE SCHOOL AND HIGH SCHOOL PUT TOGETHER.

THERE IS NO TV IN HEAVEN. (THERE IS TV IN HELL, HOWEVER.)

SCHOOL IS HELL

(BUT THE REAL WORLD IS WORSE)

LESSON 16: HOW TO GET INTO THE COLLEGE OF YOUR CHOICE

OR AT LEAST A NEARBY COMMUNITY COLLEGE

HOW TO TELL BY MERELY GLANCING AT THE MAIL WHETHER OR NOT YOU HAVE BEEN ACCEPTED TO THE COLLEGE OF YOUR CHOICE

THICK ENVELOPE — GOOD!
THIN ENVELOPE — BAD!
POSTCARD — NO. — UH OH.

WHY GO TO COLLEGE?

SO FAR IN LIFE, YOU'VE BEEN STUCK WITH:

- IRKSOME TESTS
- ANNOYING BUSYWORK
- IRRITATING GRADES
- POINTLESS RULES
- YOURSELF

WELL, COLLEGE WON'T CHANGE THAT.

BUT YOU **DO** GET TO ESCAPE FROM YOUR FAMILY!!

Q: WHAT ABOUT THE ALTERNATIVES?

A: YEAH. RIGHT.

LOW-STATUS JOB

DISHES COMIN' THROUGH

EARLY MARRIAGE

CHANGE THE CHANNEL

SHUDDUP

LIVING WITH YOUR PARENTS

LISTEN, MISS SMARTYPANTS, YOU'RE GROUNDED.

NO WAY, DAD

THE ARMY

WHAT WAS I THINKING?

000

HIGH SCHOOL STUDENTS PATIENTLY AWAITING WORD ON COLLEGE ACCEPTANCE. NOTE SICK FEELINGS IN PITS OF STOMACHS.

STILL HAVE DOUBTS?

YES. EVEN THOUGH I AM ABOUT TO GET MY HIGH SCHOOL DIPLOMA, I FEEL LIKE A FRAUD. I CAN BARELY READ, I HAVE ONLY THE VAGUEST IDEA OF HOW TO PUT A SENTENCE TOGETHER, MATH BAFFLES ME, AND MY SENSE OF INTELLECTUAL CURIOSITY HAS BEEN DEADENED BY YEARS OF BOREDOM. HOW DARE I GO TO COLLEGE?

RELAX, PAL. BECAUSE YOU DIDN'T LEARN ANYTHING, IN COLLEGE YOU AND YOUR FRIENDS WILL GET TO TAKE HIGH SCHOOL ALL OVER AGAIN. IT'S REQUIRED!

YOUR COLLEGE PREPARATION TIMETABLE

KINDERGARTEN –8TH GRADE	DON'T SWEAT IT. NO MATTER WHAT THEY SAY, YOUR SCHOOL RECORD WILL NOT FOLLOW YOU FOR THE REST OF YOUR LIFE.
9TH GRADE	START SWEATING. BEGIN PLANNING UNPLEASANT COLLEGE PREPARATORY SCHEDULE. PICK DIPPY EXTRACURRICULAR ACTIVITIES THAT WILL LOOK GOOD ON YOUR COLLEGE APPLICATION.
10TH GRADE	LET THE FRETTING COMMENCE. BECOME OBSESSED WITH YOUR GRADE POINT AVERAGE. CONTINUE DIPPY EXTRACURRICULAR ACTIVITIES.
10TH GRADE SUMMER	WORRY ABOUT THE 11TH GRADE.
11TH GRADE FALL	TAKE PRELIMINARY APTITUDE TESTS. VOMIT AFTERWARDS. CHECK OUT COLLEGE GUIDES TILL YOUR EYES GLAZE OVER.
11TH GRADE SPRING	TAKE APTITUDE TESTS. VOMIT BEFORE AND AFTER.
11TH GRADE SUMMER	TRY TO IGNORE SLOW SINKING SENSATION. DRINK A LOT OF BEER.
12TH GRADE FALL	CONTINUE FRENZIED DIPPY ACTIVITIES. APPLY TO SCHOOLS. TAKE APTITUDE TESTS AGAIN. VOMIT BEFORE, DURING BREAK, AND AFTER.
12TH GRADE SPRING	PREPARE FOR ARROGANT JOY OR DESPERATE SHAME. WHATEVER HAPPENS, RELAX. IT'S NOT THE END OF YOUR LIFE. IT'S JUST THE BEGINNING OF THE END.

SCHOOL IS HELL
OR
THIS IS THE FIRST SEMESTER OF THE REST OF YOUR LIFE

LESSON 17:
HOW TO GOOF OFF IN COLLEGE AS MUCH AS EVERYONE ELSE

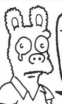

IN HIGH SCHOOL, THE TEACHERS CARED ABOUT HUMILIATING, PUNISHING, AND SQUELCHING ME. IN COLLEGE, THEY JUST DON'T CARE.

BASIC RULES

AVOID ADMINISTRATORS.

SKIM THE REQUIRED READING. SKIP EVERYTHING ELSE.

WRITE VAGUE, SPINELESS PAPERS.

CRAM.

BLOT OUT ANY KNOWLEDGE INADVERTANTLY ABSORBED IN CLASS DURING THE WEEK WITH BRAIN-DAMAGING DEBAUCHERY ON THE WEEKEND.

Q: WHEN DOES THE FABLED "SOPHOMORE SLUMP" BEGIN?

A: OCTOBER OF YOUR FRESHMAN YEAR.

Q: HOW LONG DOES IT LAST?

A: ANYWHERE FROM 6 MONTHS TILL DEATH.

FRESHMAN FAUX-PAS!!

NEVER TALK ABOUT:

➤ HOW COOL YOU WERE IN HIGH SCHOOL

I WAS IN CHARGE OF THE REFRESHMENT COMMITTEE AND THE MURAL COMMITTEE AT THE SAME TIME!! CAN YOU BELIEVE IT?!!

➤ HOW MUCH YOU LOVE AND RESPECT YOUR PARENTS

MY MOM AND DAD CARE ABOUT ME SO MUCH THEY'VE PLANNED MY WHOLE LIFE FOR ME! IT'S GOING TO BE JUST LIKE THEIRS!!!

➤ HOW YOU NEVER HEARD SUCH FILTH BACK AT THE FARM

IF MY GRANDPAPPY WERE HERE HE'D WASH OUT ALL YOUR MOUTHS WITH SOAP! AND THAT INCLUDES YOU, PROFESSOR!!!

SHOULD I JOIN A FRATERNITY OR SORORITY?

AREN'T THEY ALL JUST REACTIONARY, XENOPHOBIC ENCLAVES OF SUPERFICIAL, CONFORMIST LITTLE SNOBS?

OH MY GOODNESS, NO!! GOING GREEK IS FUN!!!! IT'S JUST LIKE SUMMER CAMP, ONLY WITH BEER, DRUGS, PARTIES, PRANKS, PADDLING, AND HAZING. TRUE, THE ATMOSPHERE IS A BIT ANTI-INTELLECTUAL, BUT WHO GIVES A HOOT WHEN YOU'RE THROWING UP WITH YOUR OWN KIND?

FLIPPING OUT-- THE 5 WARNING SIGNS

① YOU STUDY INTENTLY FOR 3 HOURS BEFORE YOU REALIZE YOUR TEXTBOOK IS UPSIDE-DOWN.

② YOU BEGIN LICKING YOUR CHOPS IN ANTICIPATION OF ANOTHER STARCH-FILLED CAFETERIA FEAST

③ IN THE MIDDLE OF A LECTURE, YOU LEAP TO YOUR FEET, POINT ACCUSINGLY AT THE TEACHER, AND SHOUT "AU CONTRAIRE, MON FRÈRE!"

④ YOU OFFER TO DO YOUR ROOMMATE'S LAUNDRY BECAUSE YOU HAVE NOTHING ELSE TO DO.

⑤ YOU PLAY GUITAR IN THE DORM STAIRWELL BECAUSE YOU HOPE TO MEET NEW PALS.

IF YOU FIND YOURSELF PLAYING FOOSBALL IN THE STUDENT LOUNGE MORE THAN ONCE, SEEK COUNSELING IMMEDIATELY.

IS COLLEGE HARD OR EASY?

IT'S EASY!

JUST REMEMBER THE 3 MAGIC WORDS!

SINK OR SWIM!!!

LIFE IN HELL

SCHOOL IS HELL

OR

3 CREDITS SHY OF GRADUATIN'

LESSON 18: THE 9 TYPES OF COLLEGE TEACHERS

LOOKING FOR LEISURE?

ROCKS FOR JOCKS 101

FOLLOW THE ATHLETES.

THE STEADY DRONER

NONSTOP NASAL MONOTONE

ADVANTAGES: ORGANIZED, PREPARED.
DRAWBACKS: IS ANNOYED BY SNORING.
WARNING: THIS IS LIFE.

THE DISDAINFUL TEACHING ASSISTANT

HUMPH

ADVANTAGES: NONE.
DRAWBACKS: VINDICTIVE, MERCILESS.
WARNING: IF YOU HANG AROUND LONG ENOUGH, YOU COULD TURN INTO ONE.

THE MIGHTY FAMOUS BIGSHOT

?

ADVANTAGES: EXCITING, IMPRESSIVE.
DRAWBACKS: DISDAINFUL TEACHING ASSISTANT DOES THE TEACHING.
WARNING: BEWARE OF BAIT-AND-SWITCH.

THE BELOVED BABBLING GRANDPA WITH TENURE

SO THEN... SO THEN... WHERE ARE MY GLASSES?

ADVANTAGES: EASY, RELAXING.
DRAWBACKS: CRANKY, OLD-FASHIONED.
WARNING: MAY FLUNK YOU IF HIS BOWELS ARE ACTING UP THAT DAY.

THE GENIUS FROM ANOTHER DIMENSION

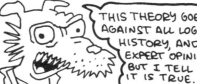

THIS THEORY GOES AGAINST ALL LOGIC, HISTORY, AND EXPERT OPINION, BUT I TELL YOU IT IS TRUE.

ADVANTAGES: LOONY, ENTERTAINING.
DRAWBACKS: LOONY, SCARY.
WARNING: MAY TURN YOU INTO BELIEVER.

OL' GLOOM & DOOM

THE THOUGHT OF SUICIDE IS A POWERFUL SOLACE: BY MEANS OF IT ONE GETS THROUGH MANY A BAD NIGHT.

ADVANTAGES: A CLOSE-UP GLIMPSE OF A SOUL IN TORMENT.
DRAWBACKS: MAKES YOU THINK ABOUT CREEPY STUFF.
WARNING: THE JOKE GETS OLD AFTER AWHILE.

THE SINGLE-THEORY-TO-EXPLAIN-EVERYTHING MANIAC

THE NATION THAT CONTROLS MAGNESIUM CONTROLS THE UNIVERSE!!!

ADVANTAGES: EASY TO PLEASE.
DRAWBACKS: PARROTING ISN'T LEARNING.
WARNING: THEORY MAY BE CORRECT.

THE INCOMPREHENSIBLE BRILLIANT FOREIGNER

DE VONSTIG IN DER SCHLONDO VEN--HOW YOU SAY--"GROOVY"--KREBBLER OSTEN VON~--

ADVANTAGES: HAS A GREAT REPUTATION.
DRAWBACKS: NO TRANSLATORS AVAILABLE.
WARNING: WILL DRIVE YOU INSANE.

NICE LITTLE NOBODY

I SEEM TO HAVE FORGOTTEN MY LECTURE NOTES AGAIN.

ADVANTAGES: EASY TO IGNORE.
DRAWBACKS: MAKES YOU WONDER WHY YOU'RE IN COLLEGE.
WARNING: THIS IS LIFE.

LIFE IN HELL

©1987 BY MATT GROENING

SCHOOL IS HELL
or
UH OH

LESSON 20: SCHOOL'S OUT

YOU DID IT! YOU GRADUATED!! WHAT A MOMENT!! I CAN JUST IMAGINE ALL THE GRAND PLANS, CREATIVE IDEAS, AND LOFTY GOALS THAT MUST BE RUNNING THROUGH YOUR BRAIN RIGHT NOW!!

NOW WHAT?

SCHOOL'S OUT! SCHOOL'S OUT! TEACHER LET THE MONKEYS OUT! ONE WENT EAST! ONE WENT WEST! ONE WENT UP THE TEACHER'S DRESS!

--TRADITIONAL GRADE SCHOOL CHANT

THE BIG PAY-OFF

CONGRATULATIONS! YOU'VE DEVOTED YOUR ENTIRE LIFE SO FAR TO HOPPING THROUGH SCHOLASTIC HOOPS FOR PETTY, MEANINGLESS REWARDS. NOW ALL THAT FRANTIC HOPPING IS ABOUT TO BE REWARED-- YOU'RE ABOUT TO EMBARK ON A CAREER OF MEDIOCRITY AND POWERLESSNESS AS PART OF A GIGANTIC BUREAUCRACY WHERE NOTHING YOU DO OR SAY WILL EVER REALLY MATTER, WHERE YOU WILL NEVER BE YOUR OWN BOSS, WHERE YOU WILL SPEND YOUR WAKING HOURS STRIVING TO EARN ENOUGH MONEY TO BUY MATERIAL GOODS THAT WILL NEVER SATISFY YOU.

WELL, SHUCKS -- AT LEAST I'M HAPPY. I'D RATHER BE HAPPY THAN SMART.

YOU JUST **THINK** YOU'RE HAPPY.

WELL, YOU JUST THINK YOU'RE SMART.

WHICH RABBIT GOT TOO MUCH EDUCATION?

EDUCATION IS NOT THE SUM TOTAL OF KNOWLEDGE LEARNED, BUT AN ONGOING PROCESS OF ASKING QUESTIONS. SOMEDAY, WHEN IT'S ALMOST ALL OVER, YOU'LL BE ABLE TO KICK BACK AND SAY:

HOW IN HELL DID I END UP HERE?

THE HORRIBLE SECRET OF ADULTHOOD

THE BULLIES, CHEATERS, TATTLETALES, AND SNIVELING TOADIES WHO TORMENTED YOU IN SCHOOL ARE NOW TRYING TO SELL YOU INSURANCE, EXPLAINING WHY A PAYRAISE FOR YOU IS CURRENTLY IMPOSSIBLE, INFORMING YOU YOUR TAX RETURN IS BEING AUDITED, AND TELLING YOU WHY YOUR COUNTRY HAS JUST DECLARED WAR.

BINKY!! REPORT TO MY OFFICE IMMEDIATELY!! AND WIPE THAT DISGUSTING SIMPER OFF YOUR FACE.

SCHOOL'S OUT! SCHOOL'S OUT! TEACHER LET THE MONKEYS OUT! ONE WAS JAILED! ONE PREVAILED! BOTH ASKED GOD: "HOW HAVE I FAILED?"

--TRADITIONAL GRAD SCHOOL CHANT

BONUS POINTS

YOU MAY WISH TO ADD TO YOUR LIFETIME SCORE BY GIVING UP ONE OR MORE OF THE FOLLOWING:

 YOUR BRAIN

 YOUR BODY

 YOUR SOUL

FURTHER BONUS POINTS MAY BE ACCUMULATED BY DEPRIVING OTHERS OF ANY OF THE ABOVE.

NEXT: FINAL EXAM

LIFE IN HELL

SCHOOL IS HELL

THE EXCITING CONCLUSION

LESSON 21: FINAL EXAM

MAY I LEAVE YOU WITH ONE SMALL THOUGHT?

GO, MAN.

JUST REMEMBER: THE UNEXAMINED LIFESTYLE AIN'T WORTH LIVIN'.

OH CHEER UP.

COMPLETE THE FOLLOWING PASSAGE:

THOSE WHO CAN, DO. THOSE WHO CAN'T, TEACH. THOSE WHO CAN'T TEACH, COUNSEL. THOSE WHO CAN'T COUNSEL, ADMINISTRATE. THOSE WHO CAN'T ADMINISTRATE, ENTER DATA INTO THE COMPUTER. THOSE WHO CAN'T ENTER DATA INTO THE COMPUTER, TAKE DICTATION. THOSE WHO CAN'T TAKE DICTATION, ALPHABETIZE FILES. THOSE WHO CAN'T ALPHABETIZE FILES, ANSWER THE PHONE. THOSE WHO CAN'T ANSWER THE PHONE, FRY HAMBURGERS. THOSE WHO CAN'T FRY HAMBURGERS, RUN THE CASH REGISTER. THOSE WHO CAN'T RUN THE CASH REGISTER, WAIT ON TABLES. THOSE WHO CAN'T WAIT ON TABLES, CARRY DIRTY DISHES TO THE KITCHEN. THOSE WHO CAN'T CARRY DIRTY DISHES TO THE KITCHEN, WASH THE DIRTY DISHES. THOSE WHO CAN'T WASH DIRTY DISHES, PEEL POTATOES. THOSE WHO CAN'T PEEL POTATOES, BUFF THE FLOOR. THOSE WHO CAN'T BUFF THE FLOOR, HAUL OUT THE GARBAGE. THOSE WHO CAN'T HAUL OUT THE GARBAGE, WRITE POETRY. THOSE WHO CAN'T WRITE POETRY, WRITE CLEVER LETTERS TO THE EDITOR. THOSE WHO CAN'T WRITE CLEVER LETTERS TO THE EDITOR, WRITE ANGRY LETTERS TO THE EDITOR. THOSE WHO CAN'T WRITE ANGRY LETTERS TO THE EDITOR, SPRAYPAINT GRAFFITI. THOSE WHO CAN'T SPRAYPAINT GRAFFITI, WRITE SCREENPLAYS. THOSE WHO CAN'T WRITE SCREENPLAYS, WRITE TV SCRIPTS. THOSE WHO CAN'T WRITE TV SCRIPTS, READ SCRIPTS FOR THE STUDIOS. THOSE WHO CAN'T READ SCRIPTS FOR THE STUDIOS, ACT. THOSE WHO CAN'T ACT, TAKE ACTING CLASSES. THOSE WHO CAN'T TAKE ACTING CLASSES, SING. THOSE WHO CAN'T SING, SING ROCK 'N' ROLL. THOSE WHO CAN'T SING ROCK 'N' ROLL, SING IT ANYWAY. THOSE WHO CAN'T SING IT ANYWAY, BECOME DEPRESSED. THOSE WHO CAN'T BECOME DEPRESSED, GET BITTER. THOSE WHO CAN'T GET BITTER, GET CONFUSED. THOSE WHO GET CONFUSED, STAY CONFUSED. THOSE WHO STAY CONFUSED, FIND IT DIFFICULT TO COMPLETE UNFINISHED SENTENCES. THOSE WHO FIND IT DIFFICULT TO COMPLETE UNFINISHED SENTENCES, _____.

LIFE IN HELL

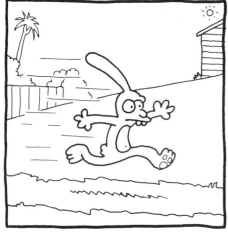

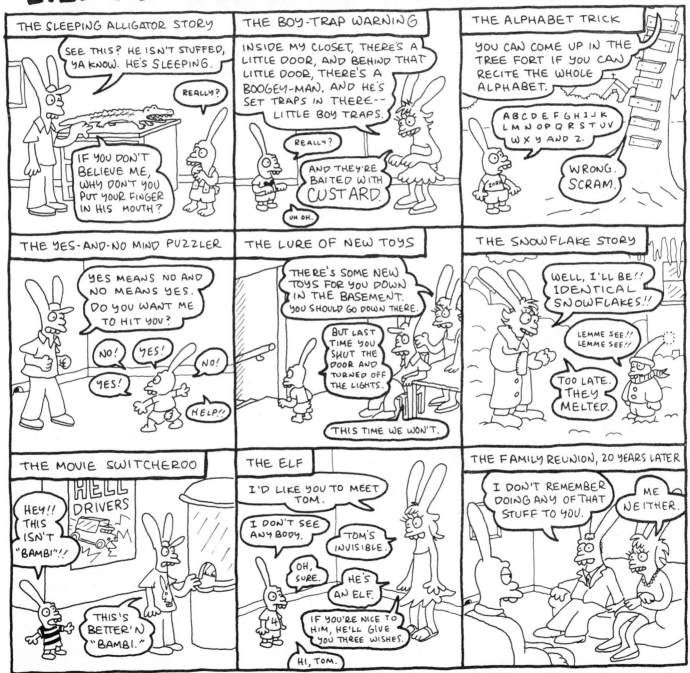

LIES I TOLD MY YOUNGER SISTERS

OR, "LIES MY OLDER BROTHER AND SISTER TOLD ME, REVISITED"

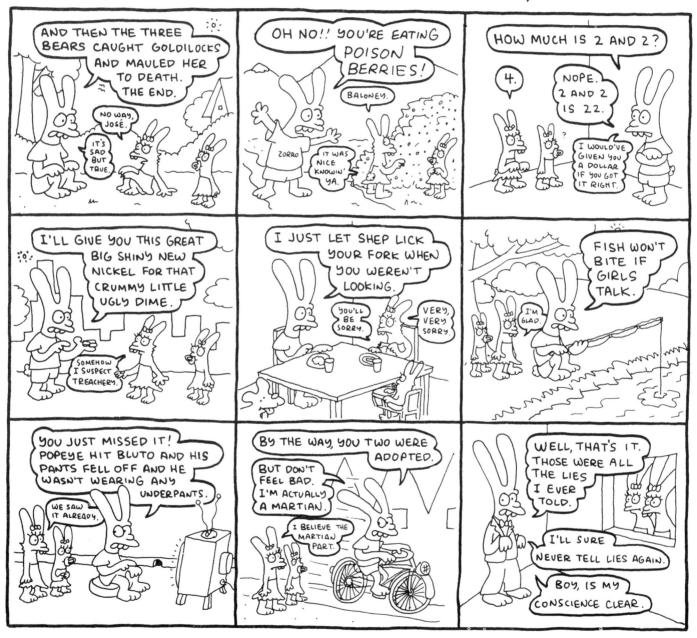

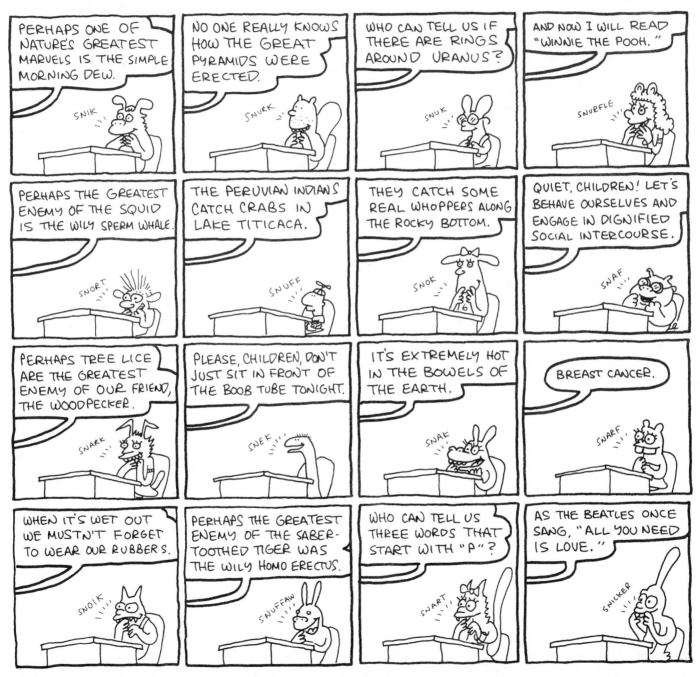

LIFE IN HELL

TWENTY YEARS AGO -- IN APRIL, 1965 -- I BEGAN KEEPING A DIARY. HERE IT IS.

MY 5th GRADE DIARY

PART ONE

BY MATT GROENING

April 5, 1965
Today it was nice out. Mr. Shute, my teacher, wasn't in a good mood.

If you get in trouble you have to run laps around the field for a half hour. Only six kids got in trouble, including me.

Today Spike got in trouble for scattering trash around his desk so he had to clean every desk on the 2nd floor of the school.

When he was holding a broom behind Mr. Shute's back he shook it at him and Mr. Shute saw.

Boy, I wonder what happened when he took Spike out of the room.

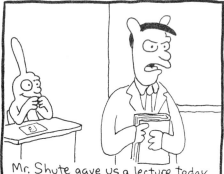

Mr. Shute gave us a lecture today because somebody dropped an encyclopedia out the window. It almost hit some guys.

It seems like I have been in the 5th grade a million years.

Oh no, I just remembered I have to get a haircut tomorrow. Maybe Mom will forget.

LIFE IN HELL

MOST OF US HAVE FORGOTTEN WHAT IT WAS LIKE TO BE IN SCHOOL.
I TOOK NOTES.

MY 5th GRADE DIARY

PART TWO

BY MATT GROENING

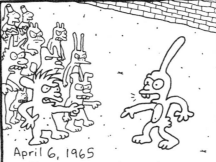

April 6, 1965

7 people got in trouble today, including me. During recess some kids were cheating and I was yelling at them and they were yelling at me.

They told Mr. Shute and he made me go to the principal's office. I am in the office now writing this.

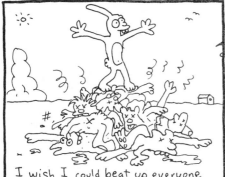

I wish I could beat up everyone who got me in trouble but I would just get in more trouble.

I got problems enough for saying Mr. Shute is the worst teacher in my life. Boy I'm in trouble.

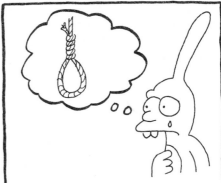

Maybe I should commit suicide. P.S. I got the haircut.

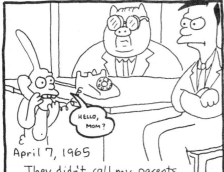

HELLO, MOM?

April 7, 1965

They didn't call my parents. Instead, they sat there and made me call them. Lucky my dad went on a trip.

The principal talked to me and Mr. Shute in his office. He talked about Babe Ruth. I said I would be good and he said we'll see the progress on Friday.

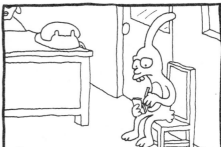

Spike N. and me got in trouble today. Spike threw a spitwad and I said quit it. You weren't supposed to talk so we both got in trouble. I had to go back to the office again.

YES, THIS IS TRUE, EXCEPT THE NAMES.

MY 5th GRADE DIARY

PART THREE

BY MATT GROENING

April 8, 1965

Not to many guys got in trouble today. I did. During English Spike was making wisecracks so Mr. Shute kicked him out of the room. He stood on his tip toes and looked in the window on the door and made faces at me. Just now Mr. Shute let Spike in the room. He made him stand at attention in the corner without leaning against anything. Tomorrow we have to work on memorising poems. Ecch! I had to stay after school for 15 minutes.

April 9, 1965

Not very many guys got in trouble today. After school I went to my swimming lessons. I know how to swim real good, but I practice anyway to get better. Tomorrow I have to get

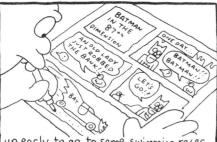

up early to go to some swimming races. I hope I'll win. I got to stay over night at Nigel's house. For dinner we had ham. Melvin, Nigel's little brother, kept throwing food at me. After dinner we drew comics and watched TV until Melvin's father told us to go to bed early, so I could go to the races early. We were supposed to be in bed by 9:00, but we went to bed at 11:30.

April 10, 1965

I lost at the races.

April 12, 1965

Today Mr. Shute said, "If you're not quiet when we go out to play softball, we'll put our heads on our desks for ½ an hour." Somebody talked.

April 13, 1965

Nigel is allergic to chocolate

and oranges. When he eats them his face gets puffed up like a monkey. Spike was making a spitwad and Mr. Shute said to spit it out and put his name on the board. He heaved the spitwad out the window. He really

got in trouble. Altogether, 10 guys got in trouble today. In the afternoon Mr. Shute cracked a joke. Spike made a real fake laugh. When everyone else stopped laughing he just kept on. During recess Nigel threw a bat at me and it hit me in the head. Then I pounded him. Then Freckles threw a ball as hard as he could at me just cause I bounced a ball off his head. He was standing 6 feet away when he threw it.

April 14, 1965

Its the Anniversary of the

Halifax Independence Resolution today. I loaned Freckles 11¢.

April 15, 1965

I forgot to tell you why I am keeping this. It is because someday when I am prez of the U.S. or something like that, I'll publish it and make a lot of money if I don't die. Only 3 people got in trouble today. No, 4 did. Lice Head, Freckles, and Jeff got in trouble. So did Spike. When you get in trouble you have to write your name on the board so he can remember whose in trouble. Some guys write their name small so he can't see it, but he does anyhow. Well, Spike wrote his name in GIANT letters across the board. He wrote so big he couldn't get the "E" on the board. Shute took Spike down to the principal.

MORE NOTES FROM THE
FUN-FILLED, HAPPY-GO-LUCKY,
CAREFREE DAYS OF YOUTH

My 5th GRADE DIARY

PART FOUR

BY MATT GROENING

April 17, 1965

Today me and dad got up early and drove to the McKenzie R. We went there to watch the guys go down the rapids in rafts and boats. When we got there we had to wade over to this island. The water was real cold. One boat was just 100 intertubes all tied together. It was real neat. On the island I found a newspaper. It had all these gory news articles. One was about this lady who spanked her daughter to death. They also showed this picture of a man with his head cut off. He tried to crawl under a train.

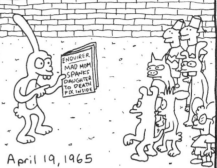

April 19, 1965

Today I took the paper to school. Lots of guys thot it was cool. I sold it to Bill Butler for 20¢. He said he was going to frame the picture of

the man with his head cut off. But Mr. Shute took it away and ripped it up. Bill cried. What a baby! All together, 10 people got in trouble today. Some guys got in trouble twice. I didn't. I only got in trouble once. After school I went to the store to get another copy of the newspaper. I told mom I went to the library. I've decided I was a sucker to buy it. At dinner I told dad about some things in school that I thot were pretty funny, but Dad got mad. Next time I will keep my mouth shut.

April 20, 1965

It's Hitler's birthday today. Spike can strike a match across his teeth. 6 guys got in trouble today. I didn't. Jim and Joe were both

trying to catch a baseball and they ran into each other. Joe really got mangled up. He is going to really have a big bump on his head.

April 21, 1965

At school the person that makes up the best slogan about keeping the school clean gets it printed in the school bulletin. The best one in a month gets a prize. We don't know what the prize is. I won once and got it printed. My slogan was Keep the school spic and span,

It is not a garbage can.

April 22, 1965

People got in trouble 26 times today. Spike N. was whispering in the library so Mr. Shute made him write a 1000 word essay. After

school I went to David Weinman's birthday party. We went to the circus. It was really cool. The tiger peed on the ball and the trainer put his hand in it. I couldn't believe it.

April 23, 1965

Mr. Shute taped my mouth shut all afternoon because he saw me whispering to Freckles Jackson. Every one laughed when he put the tape on. I guess that is why he did it, to make me feel stupid.

MORE TROUBLE.

MY 5th GRADE DIARY

PART FIVE

BY MATT GROENING

April 24, 1965

It was my sister, Lisa's birthday yesterday. She had a party. She went rollerskating. One of the presents she got was chocalate toothpaste. I got to taste Lisa's toothpaste today. It makes you want to throw up. In the afternoon Nigel and me went to the zoo. It was real neat. After we went to the zoo we went to the museum. Outside their was a passenger car from a train on display. It was dumb because the doors were locked and you couldn't get inside. Then we found out the

window on the door was broken. We reached inside the door and opened it from the inside. We went in and closed the door. All the kids wanted to get in but we wouldn't let them. Suddenly some

teenagers yelled they were gonna get us and started over to one end of the train. You bet we were scared! We ran to the other end and opened the door but there

was a tall gate that wouldn't swing open. We looked around but the teenagers weren't there. They had gone away. After while a police man came. When he started to get in the train and get us we ran to the other end. This time we climbed over the gate and jumped. Nigel went first. Just as he hit the ground and started to run, the policeman came. I thot I would get arrested, but I escaped. You bet we were lucky!

April 26, 1965

I HATE MR. SHUTE! I got in trouble for talking so Mr. Shute arranged the desks so I am by myself in front of his desk. Spike and Nigel can throw

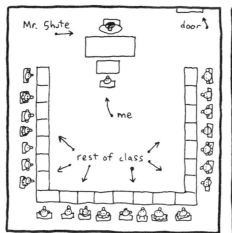

things at me and I won't be able to see it. I can't do anything.

April 27, 1965

Boy, some of the guys at Ainsworth are real crums. Sometime I'll wright about em. In math today I missed 28 problems. Who cares. I skipped breakfast and lunch today.

April 28, 1965

Boy, I sure hate Mr. Shute. Today just cause one guy was cheating he made us do excersizes for the whole period. It was real crummy. First we had to do jumping jacks. Then situps.

Then pushups. Then some others. After about 20 minutes (which doesn't seem very long but really it is. If you don't believe me try it) he let us stop. Then we had to run 3 laps around the feild.

The last 3 guys had to do 3 extra laps and 25 pushups. Nigel, Brad, and David had to do the extra 3 laps and stuff. They cried

April 29, 1965

Today I saw the best fight I've seen in a long time. It happened on the bus on the way to school. Mealy and his little brother got into an argument. First they were hitting but after awhile they really started slugging. All this happened wile they were sitting down. Suddenly Mealy dropped a cake he had in his lap right on the floor.

April 30, 1965

Mr. Shute got so mad today he threw some chalk at Spike. Spike ducked. I got in trouble so during

recess I had to stand in the corner under the shed. I didn't have anything to do so I taught myself to blow spit bubbles off the end of my tongue.

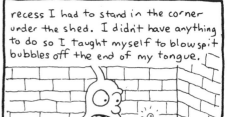

May 3, 1965

I have to write "I must remember to be quiet in class" 500 times and turn it in tomorrow.

X-Ray Specs. Dirt clods.
The Life Story of the Paramecium.
The Life Cycle of the Liverfluke..
Other People's Feelings.

MY 5th GRADE DIARY

PART SIX

BY MATT GROENING

489 I must remember to be quiet
490 I must remember to be quiet
491 I must remember to be quiet
492 I must remember to be quiet
493 I must remember to be quiet
494 I must remember to be quiet
495 I must remember to be quiet
496 I must remember to be quiet
497 I must remember to be quiet
498 I must remember to be quiet
499 I must remember to be quiet
500 I must remember to be quiet

For some reason, Matt tells me that I must sign this. Homer Groening
For some reason, Matt tells me that I must sign this. Homer Groening
For some reason, Matt. Oh well. You get the idea. Homer Groening

May 4, 1965
　　When I turned in my 500 sentences Mr. Shute tried to rip it up but I made him give it back. After school Jeff R. and me went downtown to see a magic store. We were going to buy some giant balloons but they costed to much. At the store we saw some glasses called X-Ray Specs. You can see through things with them. I wonder if it really works. I was gonna get it but it cost a dollar and that is too much.
May 5, 1965
　　I'm really not gonna get those X-Ray Specs now. Spike told me they

just got a picture of some bones on the glasses. No matter what you look at, your hand or a wall, you'll see bones. Nigel's face really got puffed up from the allergy today. The right side of his mouth got puffed up, the left of his nose got puffed up and his left eye got all swollen. He looked like a monster.
May 6, 1965
　　Nothing much happened today. After school I went to the Multnomah Athletic Club. Me and glenn and Spike and Randall and Cal went down under the Multnomah Stadium and

played tag in the dark at the handball courts. After we got tired of that we had a cool dirt clod fight. While all the other guys

were fighting down below, I climbed up these old rotten stairs you weren't supposed to use, because they were rotten. When I got up there

I could throw dirt clods on the guys below, who didn't know I was up there. After awhile a guy told us to get out, so we left. After I went swimming I went home.
May 7, 1965
　　We have to see the dumbest movies at school like The Life Story of the Paramecium. I'm making a graph on how many times people get in trouble in our class. Six guys got in trouble today, including me.
May 11, 1965
　　Today Spike got in trouble cause when we were watching a movie on

Brazil they showed this picture of some pigs. Spike said, "There's Francine." Francine is real fat, and Mr. Shute got real mad. He got so mad he made Spike write a

1000 word essay on the life cycle of the liverfluke. The reason Mr. Shute thot of that was 'cause we saw a movie yesterday called "Other People's Feelings." It was old and corny. Most old things are. I'd say the movie was made in the 40's. It was about this girl named Judy who had a bottle of perfume. When she went to school a boy bumped into her and she dropped the perfume all over the floor. Then he called her Stinky all the time. Finally she

starts crying. Right during class. Then the stupid narrator says "What should Judy have done?" Most everybody said Pound the boy.

BABOONS, RECESS, FLYING SAUCERS, POLITICS, MODERN ART, TROUBLE, AND GIRLS

MY 5th GRADE DIARY

PART SEVEN

BY MATT GROENING

May 8, 1965

Today me and Jeff went to the zoo. At the zoo we found a bag of carmel corn in the garbage can. We fed some of the carmel corn to the monkeys. We didn't eat any cause we found it in the garbage can. There was this baboon there that was real ferocious and mean, even worse than gorillas. He was the biggest and he would take all the food away from the other baboons. We'd hold out some food and he'd reach for it than we pulled it away. This made him real mad. At 1:30 Jeff went home. So did I.

May 10, 1965

6 guys got in trouble today. Jeff, Paul, Cal, and Tom have to write 1000 word essays. Jeff has to write about Luck Bringing Charms. Paul has to write about Napoleonic Wars. Cal has to write about glass blowing. Tom has to write about Volcanoes. Isn't that crusty? At Recess today we played softball. My team won them 9 to 0. I was pitcher the whole game and 1st up. I saw this ad in a mag about this book called The Hollow Earth. What a crazy book. It's supposed to be true. Here's the

article: Revealed The Underground World of Supermen Discovered by Admiral Byrd.... Under the North Pole.... and Kept Secret by U.S. Government.... Dr. Bernard, noted scholar and author of The Hollow Earth says that the true home of the flying saucers is a huge underground world whose entrance is at the North Pole opening. In the hollow interior of the Earth lives a super race which wants nothing to do with man on the surface. These supermen launched their flying saucers only after man threatened the world with A-bombs. It goes on and on. What a fake!

May 11, 1965

Today we had elections in class. We tried our usual way to get boys in the office. The girls (they are so stupid) couldn't figure it out. You see, we'd keep on having nominations for some office until someone moved they should be closed and all that stuff. Some boy would nominate another boy. No matter who it was no other boy would nominate <u>any</u> other boy. And girls would nominate more and more. When they nominated 7 then we'd close the nominations. The room is half boys, half girls, so when they split up their

vote, we'd all vote for the boy. Boy, was it cool. But they wised up. Now they have stopped nominating so many but still there's some dumb girls that'll nominate their best friends. So I remain until tomorrow (maybe), Matt G.

May 12, 1965

3 guys got in trouble today. The average of people getting in trouble every day is 9.21% according to my graph. At P.E. I was pitch for my team and 2nd up. We beat the other team 11 to 2. Spike has to write a 1000 word essay on Modern Art. After

school the 5th grade boy's team played the 5th grade boy's team of Hayhurst. Half their team was guys that should a been in 7th or 8th grade but they flunked. One guy was supposed to be a freshman in highschool. They beat us 15 to 3. I played shortstop two innings, got up once, struck out. All the kids will really razz us at school tomorrow.

May 13, 1965

Attention!.....
Special On The Spot News Report...
... <u>No one</u> got in trouble today.....
another Ainsworth School first....

... now back to our regular diary.... There's nothing much to tell because nobody got in trouble. The guys at school didn't razz us. (We didn't tell them.)

May 14, 1965

4 guys got in trouble today. Mr. Shute made me and Spike sit on the floor all morning with tape over our mouths because we talked and I gave a bad news report.

May 17, 1965

3 guys got in trouble today. Some dumb girls wanted to have a party at the end

of the year and get Mr. Shute a radio. He isn't worth it.

May 18, 1965

When I got to school I couldn't find my graph. I looked all over the place for it but it was gone. I don't think anyone took it.

May 19, 1965

Today was crusty. Annie got in trouble today. She has to write a 1000 word essay on "The Life and Habitat of the Mongoose." Hardly any girls ever get in trouble because they're goody goody. Annie is pretty nice for a girl, I think.

CONCLUSION

MY 5th GRADE DIARY

PART EIGHT

BY MATT GROENING

May 20, 1965

Today at school oh shoot I cant write with this dumb pencil.

May 21, 1965

Shoot, I see the spelling isnt so good in this journal. You may not believe this but I am a great speller. Its just that when I'm tired I don't spell good. Crust, I got in trouble today for groaning. Mr. Shute got mad so I get kicked out of the room. Isnt that dumb?!?? Oh, well. Sorry for me. Until I write again I remain

Matt Groening

May 24, 1965

I decided I'll never be prez of the U.S. so I think I'll stop now.

June 10, 1965

I think I'll start again. Lotsa cool jazz has happened since May 24, but I cant remember all of them. Mr. Shute sure is a bunch of swear words. A couple of days ago he gave me a 1000 word essay on the History of Football. For no reason. Other essays were Life cycle of the whale, Animal life on the Sahara

desert, witchcraft, The Fuedal Castle, life of Beethoven, diamond mining. You turn it in and he rips it up. Isnt that crusty? Yesterday these guys came over to our school from another to celebrate that they got out of school for the summer. They had these BB guns and they were shooting guys. Melvin and Fartface got hit. Then Mr. Love called the fuzz and they came and hauled em off to Junior Disneyland Hotel. If ya don't know what that means think of J. D. H. Today was the last day of school.

It was the coolest deal ya ever seed. After school me and Spike were really heaving all these water balloons all over. Then these guys came along and heaved about 10 at us. Also I told ya about the party for Shute. The girls didnt have enough money to buy him a radio so they got him sum pencils. Mr. Shute wouldn't let Spike have any refreshments but he had em any way.

P.S. Looking back at the whole school year I have but one thing to say—— I HATE MR. SHUTE!

P.S. again. I AM FREE!!!!!

©1984 BY MATT GROENING

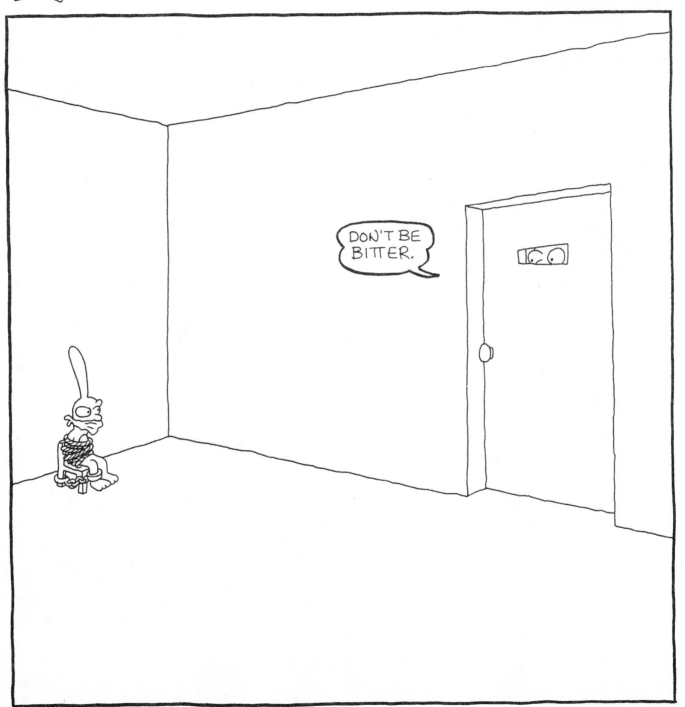

LIFE IN HELL

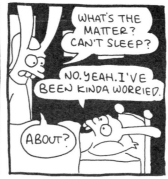

WHAT'S THE MATTER? CAN'T SLEEP?

NO. YEAH. I'VE BEEN KINDA WORRIED.

ABOUT?

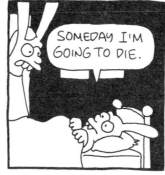

SOMEDAY I'M GOING TO DIE.

AFRAID OF DYING, EH?

YEAH.

I REALLY DON'T WANT TO DIE.

JOIN THE CLUB, PAL.

DEATH SURE IS SCARY.

SURE IS.

ISN'T THERE, YOU KNOW, LIKE ANY HOPE? JUST A LITTLE BIT?

LEMME TELL YOU SOMETHING ABOUT DEATH: THERE'S NO ESCAPE.

BUT DON'T WORRY ABOUT IT. YOU'RE NOT DEAD YET!

OH, GREAT.

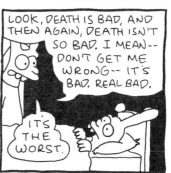

LOOK, DEATH IS BAD, AND THEN AGAIN, DEATH ISN'T SO BAD. I MEAN-- DON'T GET ME WRONG-- IT'S BAD. REAL BAD.

IT'S THE WORST.

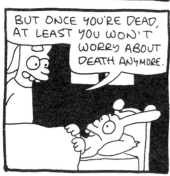

BUT ONCE YOU'RE DEAD, AT LEAST YOU WON'T WORRY ABOUT DEATH ANYMORE.

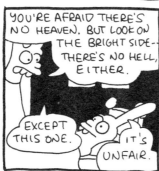

YOU'RE AFRAID THERE'S NO HEAVEN. BUT LOOK ON THE BRIGHT SIDE-- THERE'S NO HELL, EITHER.

EXCEPT THIS ONE.

IT'S UNFAIR.

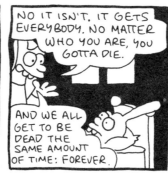

NO IT ISN'T. IT GETS EVERYBODY. NO MATTER WHO YOU ARE, YOU GOTTA DIE.

AND WE ALL GET TO BE DEAD THE SAME AMOUNT OF TIME: FOREVER.

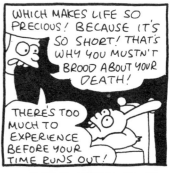

WHICH MAKES LIFE SO PRECIOUS! BECAUSE IT'S SO SHORT! THAT'S WHY YOU MUSTN'T BROOD ABOUT YOUR DEATH!

THERE'S TOO MUCH TO EXPERIENCE BEFORE YOUR TIME RUNS OUT!

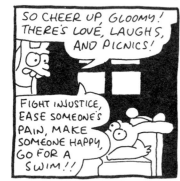

SO CHEER UP, GLOOMY! THERE'S LOVE, LAUGHS, AND PICNICS!

FIGHT INJUSTICE, EASE SOMEONE'S PAIN, MAKE SOMEONE HAPPY, GO FOR A SWIM!!

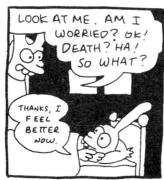

LOOK AT ME. AM I WORRIED? OK! DEATH? HA! SO WHAT?

THANKS, I FEEL BETTER NOW.

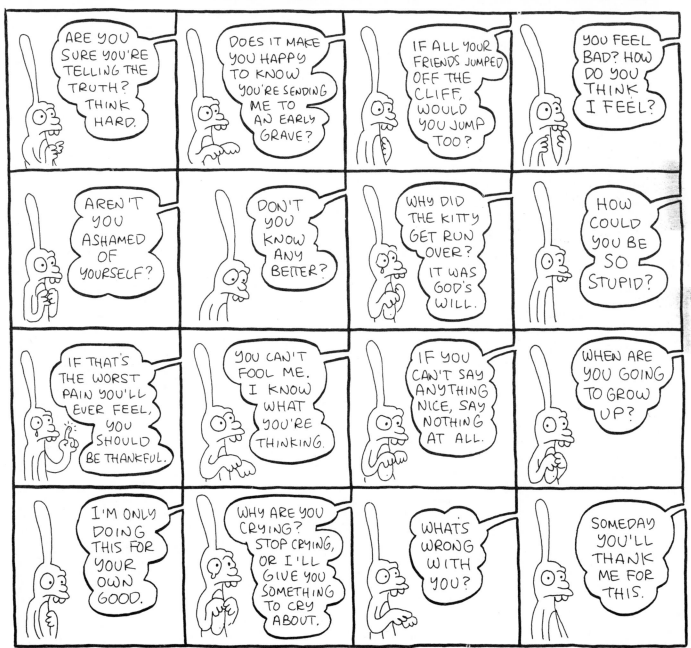

LIFE IN HELL

EVEN MORE PARENTAL BRAIN TWISTERS

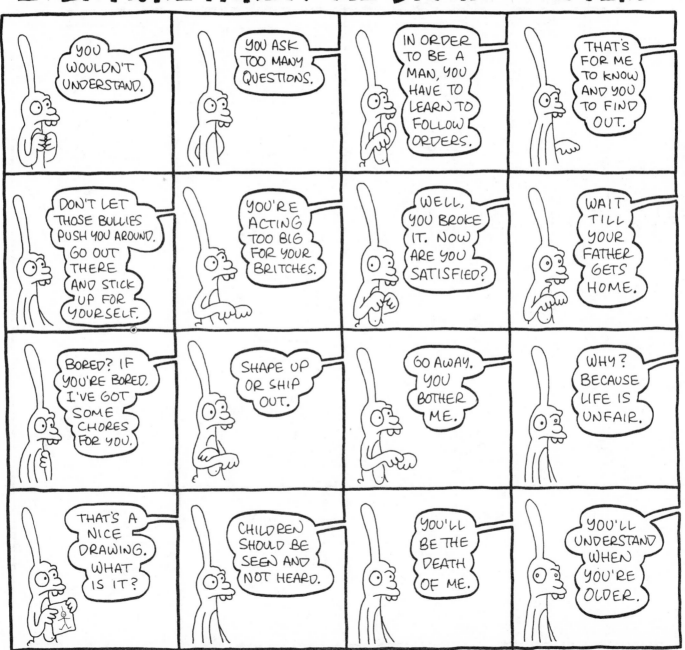

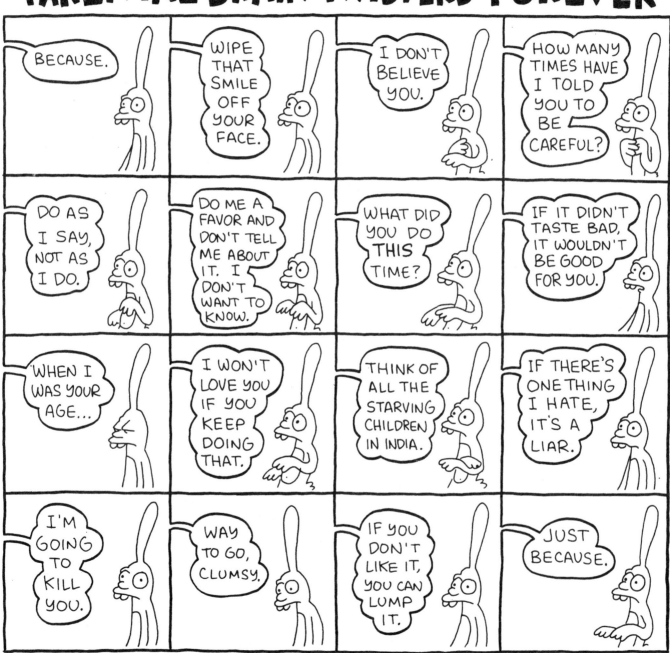

LIFE IN HELL

CHILDHOOD TRIBULATIONS

FORCED NAPS

WAITING IN THE CAR

WAITING FOR THE CARTOONS TO COME ON

FARM REPORT

HIDDEN COOKIES

FLOATING GOLDFISH

CARROTS INSTEAD OF COOKIES

BEING HOSED OFF BY MOM

BEING LEFT BEHIND BY OLDER SIBLINGS

SLAM!!

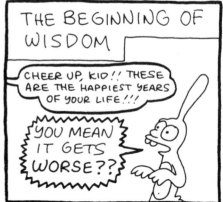

THE BEGINNING OF WISDOM

CHEER UP, KID!! THESE ARE THE HAPPIEST YEARS OF YOUR LIFE!!!

YOU MEAN IT GETS WORSE??

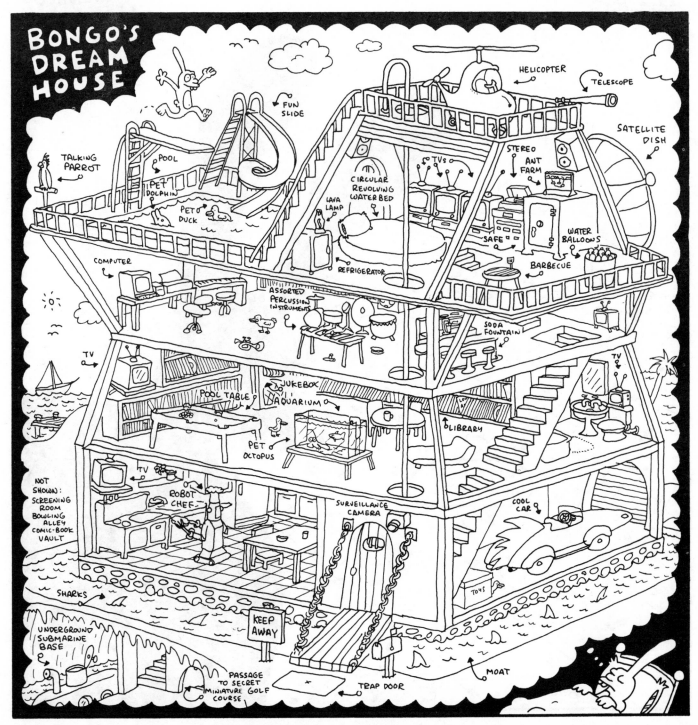